© 2005 Assouline Publishing for the present edition
601 West 26th Street, 18th floor
New York, NY 10001, USA
Tel.: 212 989-6810 Fax: 212 647-0005
www.assouline.com

First Published in the United States of America in 1999
By Universe Publishing and The Vendome Press

English translation copyright © 1999 Universe Publishing

Front cover photograph: Raymond Loewy posing in front of the Pennsylvania
Railroad Company's S1 locomotive. © All rights reserved.
Back cover photograph: Coca-Cola delivery truck with angles racks to facilitate
handling by Raymond Loewy. © All rights reserved.

Text and captions translated by Cynthia Calder.

Color separation: Gravor (Switzerland)
Printed by Grafiche Milani (Italy)

ISBN: 2 84323 774 2

RAYMOND LOEWY

PHILIPPE TRÉTIACK

ASSOULINE

r aymond Loewy's life, as described in his autobiography *Never Leave Well Enough Alone,* would have made a very bad film. There were no flaws in it. This paragon of designers left behind only a working sketch, a mere slogan from his triumphant all-American success story, which was celebrated on the cover of *Time* (October 31, 1949). The whole tale was virtually streamlined, made sterile by too much retouching. As a price for his fame, Loewy, who had transformed refrigerators into American icons, ended up crystallized as if in amber, caught in his own trap, transformed into an "over-designed" product himself. This is a sad, and almost bitter statement about current styles, which often are admired for their lack of refinement. Beauty disappoints; leaving "well enough alone" is good enough. In paying tribute to this twentieth-century artist, we must search beneath the veneer of legend for flesh and bone, beneath the strength for weakness.

Let us start with a photograph that Loewy tellingly selected in 1953 to illustrate his memoirs. He had just turned sixty. His prestige was already monumental. He had plenty of money, and his industrial design studios in New York, Chicago, London and Paris employed hundreds. This very "Harcourt-style" photograph portrays him in his prime. The club tie and striped shirt, enhanced by the cigarette holder, reflect the image of an aesthete whose words were treated like prophesy. This is Raymond Loewy as glamorized movie star—too glamorized. Something about the tilt of his head, his wavy hair, his mesmerizing fortune-teller's gaze, his initialed cufflinks, casts him in a supporting role. In a Frank Capra film, which Loewy might well have inspired, he would have played a secondary part at best. He was too well turned out not to be somebody's sidekick. Despite all his efforts, Loewy always had the allure of an Argentinean tango dancer, a flamboyant upstart who gave the impression of a flashy frozen elegance. It is cruel irony that a life dedicated to the elimination of chrome is reduced to a series of polished images.

the first of these images sparkles with seven war decorations and a few trinkets gleaned from the mud of the trenches. Raymond Loewy landed in New York in the autumn of 1919. Sporting the uniform of a French army captain, this hero of the Great War had come to join his brother, a prominent surgeon. During the crossing he strolled the deck establishing contacts. The prestige of his uniform gave him special entrée to the British consul in New York. The diplomat was captivated by the designer, who showed him numerous sketches made during the voyage. He gave Loewy a valuable referral to the owner of Macy's department store. Loewy,

who still dreamed of becoming an engineer, was unaware that his future course would change entirely as a result of this meeting. He would become a window designer, a fashion illustrator, a stylist and later a designer of offices, toasters, cars, locomotives, planes and even a spaceship! One stroke of his pencil was like a push on an accelerator. Dedicated to speed, Raymond Loewy was the embodiment of forward motion.

m eanwhile, he posed for another chromo, the cornerstone of his legend. From beginning to end, he never ceased burnishing his own story. Indeed the most beautiful of all the products to emerge from his studios was the myth conveyed by his name. Loewy was mesmerized by transportation, fascinated by anything that moved. This addiction came naturally. He was born in 1893, a few hundred yards from the Eiffel Tower, which had been completed four years earlier. It was a venerable neighbor. He always reminded everyone that he had climbed up the ladder to success at a forced march, starting from nowhere. When he arrived in New York, he set up camp on the lowest rung, right on the street. Here he is, only fifty dollars in his pocket, out of place in his uniform, manning his post on the windy corner of Broadway and Fifth Avenue, the latter an artery where he was soon to establish his most lavish office. For the moment, however, this poor "Frenchie" has only his eyes to see and his ears to hear. He is feeling the heartbeat of his new country, every pulse of it, including the most hideous—the clanging of the trolleys, the din of the scrap metal glittering with sparks, a vision of hell, where a human being could be crushed as if hurled into the heat of a blast furnace. Raymond Loewy was enthralled. Yes indeed, this country

was truly larger than life, gigantic and fierce. Here at this crossroads, stunned almost senseless, Loewy experienced an epiphany: He would take up a crusade. He would give this superpower nation a soul, a hint of French elegance, "a touch of chic."

t he next picture is more intimate. Loewy is hard at work. Even the loudest knocking will not bring him to answer the door. He is too busy. He has thrown a mass of modeling clay on the floor of his little studio. Beneath this formless heap he has buried a Gestetner duplicating machine. The boss has just delivered it to him with an order. In only two days, the greasy riveted monster must be re-created, turned into something fresh and seductive by the hands of this Raymond Loewy about whom everyone was saying such great things. Loewy sculpted, smoothed and streamlined it, implementing techniques he would systematize a few years later. His method: purify, eliminate and simplify. Out with ponderous decorations, ungainly hulks, spindly legs, all the "schmaltz" as they called it in New York, where Yiddish commingled with English. Streamlining was the byword. Without realizing it, Loewy became a dissident. In the thirties, the spirit of the Bauhaus blew through the Old World. The movement insisted on functionalism, with objects stripped down to their basic elements. Design that reconfigured, contained or hid operating mechanisms was rejected. On one side of the Atlantic, gears, assemblies, joints and machines; on the other side, enveloping encasements, round and soft forms. In Old Europe the virile right angle, in the New World a feminine curve and the first suggestion of sleek form that fifty years later, lead to organic design and the explosion of Japanese style. Loewy was the apostle of the

streamlined look, reminiscent of sleek ocean liners, which would seduce the housewives of the fifties. He stood accused of being nothing but a "stylist," but he turned his back on such criticism. What did it matter when he had all of America in his pocket?

t here were no detours between feminine curves and sales curves—just a straight line of steady achievements. Loewy, who invented the profession of industrial design and founded the American Society of Industrial Design in 1944, assumed the marketing philosophy of his adopted country with striking ease. "The goal of design is to sell," he said. And to drive the point home, he added, "The loveliest curve I know is the sales curve." He inveighed against the aesthetes of Europe, and the ring of his cash registers muffled their squawks. He simply sold more than anyone else. The Loewy touch propelled profits upward. He was as much a genius in business as in design, and soon his studios included a market research division. Loewy's father was the author of numerous economic studies and editor in chief of a financial newspaper, a vegetarian when the mood struck and an eccentric in his own right, secretly yielding to orgies of sausages on occasion. He could now be proud of his son, and with good reason. In 1948, *Time* chose Loewy for its cover, honoring a designer for the first time. Beneath the portrait, surrounded by his most famous creations, appeared the concise phrase: "He streamlines the sales curve." Was there any shot more beautiful than this one that succeeded in selling hundreds of thousands of copies?

Loewy had struggled to get this far. He had a lust for conquest. His story now becomes more like King Vidor film than a

8

Frank Capra. Think of *The Rebel*. Penniless in 1919, Loewy scraped by as a fashion illustrator. In 1928 he changed hats and threw himself into industrial design. Nine years later, his sales took off, reaching new heights. Then they plummeted. The Wall Street crash did not spare him. His reaction was to prescribe for himself the remedy of the greatest champions. He pushed harder. Since everything was going badly, he would have to make his own luck. He invested heavily, leasing a studio on the 44th floor of 500 Fifth Avenue. He furnished it luxuriously and fought his way back uphill. In no time, his capital had increased tenfold. He started thinking about even faster growth—always faster, always higher—but the next fall was harder. In 1935, a second wave of bankruptcies swept over him, but even that did not hold him back. Captain Loewy had withstood plenty of other assaults. Besides, he had just one byword, just one method: simplify. He simply rented even more beautiful, more expensive space. It was Fifth Avenue or nothing. Within just a few years, it was Fifth Avenue and everything. A photo taken at that time says it all: "Emperor Loewy," dressed to the nines, reigning over his offices, surrounded by associates, colleagues and gorgeous secretaries. In this image, the storm forgotten, he is surfing the waves of pounds, marks and dollars.

●

I n the next picture, Raymond Loewy is seen giving a little tweak, a gentle nudge, to millions of dollars. This stroke of talent which was to become his most spectacular coup, made the Lucky Strike cigarette packet of 1942 a symbol of his genius. To improve on the design of the existing packet seemed impossible, but not to Loewy. He decided to put the brand's logo, that well-known

red bull's-eye, on both sides of the box, not just one. When the packet was tossed carelessly on a table, the logo could now be seen 25 million times more often, without any additional advertising expense. This gentle nudge was a stroke of genius. In fact it was a typical Loewy touch that showed the power of his personality, his ability to magnify tenfold the slightest advantage, to optimize with a hard-hitting slogan, invariably hitting the target square in the middle. He could always find the simplest yet most profitable answer to any problem set before him. He summed up this concept, calling it the MAYA ("Most Advanced Yet Acceptable") stage, the "point from which you can advance no further" or the "shock threshold." It was no small achievement to turn a vast country upside down gradually, from its signs, slogans and posters, to its cars and even its faces. Toward the end of his life, Loewy was invited to speak at a conference. During the speech, he noticed that there was nothing on which to place his lecture notes. He decided to simply drop each sheet as it was read. The audience was captivated by the white leaves whirling toward them. That was vintage Loewy, with the elegance of gesture, the air of nonchalance, the little touch that changes everything. And change everything he did.

1

oewy's time had come. During the years after World War II, it seemed that the entire nation wanted only one thing: to own a house, a car and a garage. All that marks today's design profession—the explosion of styles, the fragmentation of the market into sectors, niches, trends—had not occurred. The American people spoke with a single voice. Ford's mass-produced Model-T was as seductive to a Kansas farmer as it was to the law clerk in Baltimore,

and later models aroused the same passion. It was an era of euphoria. Loewy began to shape the image of an entire nation with his pencil strokes, taking on more and more memorable commissions. His drawings on paper would be transformed into legends. His sketches, models and blueprints were to largely shape our current impression of the United States as a fantastic, vital country. Within a few brief years, he had created the icons of the streamlined fifties—jukeboxes, gas pumps, cigarette packets, Greyhound buses, car bodies such as the Studebaker and the fully-welded Lincoln Continental, toasters, tractors, helicopters and the ferry-boats ceremoniously welcomed into the port of New York.

t he Frenchman who had disembarked in New York in 1919 and was naturalized in 1938, who considered the stars and stripes, that star-spangled banner, an aesthetically perfect masterpiece, rubbed shoulders with the Who's Who of America. From TWA and Exxon to Shell and Coca-Cola, he covered roads with signposts and crowned buildings with logos.

Although Loewy was harder at work than ever, the era of nights spent laboring on his hands and knees was past. Now he organized, coordinated and made decisions. Other people crouched to knead the clay. Loewy would repeat the bold experiment of the Gestetner copier, a true masterpiece, countless times. First there was the Coldspot refrigerator, the form of which he so revolutionized and streamlined that it became a best-seller in America's ideal homes. Loewy's formula—more comfort at lower cost—was irresistible, even though it was an approach that had once cost him dearly. During his years as a window dresser at Macy's the prevailing rule was to stuff

displays to maximum capacity. He chose to simplify, and his minimalist style earned him an equally minimal salary. Loewy held on and eventually his luck changed. Thirty years later his ideas reigned supreme. Now he could build encasements, eliminate rivets, weld pieces of metal, always searching for a lighter and more malleable material, one that would be easier to streamline. After his own fashion, Loewy was a master of art forms, the Leonardo da Vinci of the New World. He was both engineer and visionary. He spent his days refining the silhouette of a refrigerator, his nights fine-tuning its acoustic properties. He was convinced that a soft, muted hum from the refrigerator could and should reassure the housewife. In his own way, this man, who was obsessed with speed, broke the sound barrier. Faced with any challenge, Loewy would innovate, and his sales curve reflected his willingness to take on risk. When he noticed that a waiter wearing a jacket with gold buttons got better tips than a fellow in a scruffy shirt, he turned his attention to designing uniforms that also were becoming distinct symbols of America. At the other extreme, while perfecting complex locomotives, he devoted just as much attention to the system for cleaning the motors as he did to the style of linen in the dining cars. He kept a hand in everything, always hoping to gain time and make money. To him speed was of the essence. In 1940, *Architectural Forum* wrote: "Loewy is the only American designer who can cross the United States in a car, train, or plane of his own design" (an accurate observation, even it if did omit helicopters and ocean liners). Young Raymond, who at the age of 14 had patented and marketed a miniature model of a plane under the name "Ayrel" (pronounced R.L.), had come a long way. The century that had seen the introduction of electricity, the telephone, aviation and atomic weapons, had propelled this designer

forward as he labored in its service. Raymond Loewy was the embodiment of the twentieth century. It is understandable that he would sometimes consider himself a star.

h e was enthusiastic on all fronts. During this period, great faith was placed in progress. The public had been wounded by various crises, and Loewy had reassured them by smoothing out the edges. He prospered in the post-war period. He designed the Studebaker Champion in 1948, followed by the chromeless Starlier, a flowing vehicle that served as the model for the Ford Mustang and the Pontiac Firebird. Its appearance foreshadowed the romantic drama starring James Dean as victim in his legendary drive. In 1960, Loewy put the final touches on the Avanti, featuring a hood and trunk that looked like two drops of water, a front and back that were indistinguishable from each other, and a body lowered for speed. During the war, Loewy worked for the army designing operating theaters. Conducting himself as the model citizen one would expect, he never failed to recognize the importance of his task. As a designer he felt it was vital not only to ensure the safety of railroad passengers but also to produce good designs that would ensure and maintain the long-term employment of a company's staff. When developing a new lipstick during the war, he focused first on the psychological impact it would have on the morale of American women and the indirect impact it would have on their husbands on the front. Loewy was not a philantropist; he was a practical person whose artistic sensibility was influenced by the desire to make others happy. In his dedication to a consumer society that he helped form, in his enthusiasm for factories operating at full steam, for the great

spectacle of steel plants spewing smoke across the Pittsburgh skyline, in his tribute to the American worker impeccably uniformed in a gas attendant's attire, welder's gear or nurse's uniform, there is a hint of the glorification of the Soviet hero, an echo of the Soviet realists' celebration of the proletariat. This was the Loewy style, a socialist society with a pioneer spirit, a New Deal in the world of style: revolution.

I n this revolution he would be the Great Helmsman, the Ultimate Leader; a professional helping the lost sheep return to well-being, a wonderful lifestyle and the democratic American way of life. This image of Raymond Loewy would not have displeased him. Perhaps because, from a physical perspective, he looked more like Walt Disney, revised and corrected by Tex Avery, than a Führer, he was never consumed by the megalomani a of saving humanity. (At worst, he would be taken for a Marylin Monroe with a mustache.) People talked about the fact that he never ceased recreating his image. Throughout his life he promoted his own activities as a designer as if he were a product, always chasing after photo opportunities, posing wherever he could. He invented the concept of vending machines. In Buffalo, he constructued a windowless building in order to gain storage and exhibition space. He improved mass distributing by developing a system of just-in-time distribution. He designed store windows to lure passing shoppers, cleverly positioning these windows so that women could be seen rummaging through the merchandise, knowing that their frenetic activity would capture the attention of passersby. Loewy redesigned his world into a stage on which he could see and be seen. Never stopping to take a breather; he spent his days in endless poses.

Here he is in Palm Springs, alone in order to think; at his Mexican home in Tierra Caliente; in his villa in Saint-Tropez—flitting from one to the next at top speed, playing his role in jet-set society. He kept company with Malraux and Kennedy; he was called on to help Mikoyan in the USSR. Here he is again, caught by the magazines in an astronaut's uniform behind the wheel of his Studebaker Avanti, looking like a newly-elected Miss America, flanking or flanked by (it is hard to tell) Charles de Gaulle.

While Loewy took great pleasure in flaunting his public persona, the private man's character was surprisingly discreet. Chapter thirteen of his autobiography begins: "After the war, my wife and I agreed to divorce." We are given no further information. He later married Viola Erickson, the love and passion of his life. No shadow seemed to fall over their idyllic world—perfect happiness or purified fabrication? It is impossible to say. There are certainly shady areas in Loewy's world. To Americans, he will always be remembered as the man who designed the bullet-style train, glorifying its look. Many people associate his name with Coca-Cola and mistakenly assume that he is responsible for designing the classic small bottle. (This wonderful icon, designed long before Loewy's heyday, met the need for a handheld container required by a new society "on the go." The time had come to move away from the courteous but outdated teacup and saucer.) Coca-Cola did turn to Loewy for advice, but he only landed their secondary design projects such as soda fountains and delivery trucks. While he was not responsible for the Coca-Cola bottle, he did design one for Fanta, for which he never took credit. A certain well-maintained confusion reigned over his productions.

In 1965, the merger of his various studios established the largest design company in the world. He never stopped, and everything that emerged from his workshops was signed by him. Dictatorial in nature, he demanded to be a part of it all. While he certainly contributed to the success of many companies, his genius was not great enough to save some of them, such as Studebaker, from bankruptcy. Loewy was very fond of boasting that he started the American space program and would often refer to an intimate conversation he held about it with President Kennedy. Although he was associated with the Apollo program, his contribution was modest. Still his legend is great. He is known for his invention of the panoramic upper level of the Greyhound bus and for his insistence on placing a porthole in the astronauts' cabin. Today, thirty years later, outer space and the memories of thousands of earthlings still echo with the emotion expressed by the astronauts in describing the fantastic spectacle of seeing Earth from space. Thanks to Loewy, always the star, who wanted to see and be seen.

While Andy Warhol is known for creating icons, it is Raymond Loewy who built monuments. In his process of refining, in his ability to streamline, he worked like a sculptor, integrating movement into his designs in a characteristic American way. Locomotives, cars, ocean liners—they were all monuments in motion. In other arenas he worked on transferring images, using the bullet shape on locomotives, borrowing a car door handle for a refrigerator. In literature, his work would be called a symphony of metaphors.

Loewy, who summarized this work as ten percent inspiration and ninety percent transport, once characterized his style, force,

and power as follows: "I always believed that two and two made twenty-two." In one revealing sentence, he demonstrates his way of coming to a solution so unique it is beyond the boundaries even of mathematics. He shows us one last time that he is not only a visual genius but also a brilliant visionary.

Twelve years after his death, in a world of armoires and kitchen cabinets, motors rigged up with ball bearings, cogwheels and platinum screws, countless types of poorly designed objects, their workings muddled and askew, we can imagine more than one of these devices in need of a facelift mourning the days when people would cry out in excitement at the approach of this "Frenchie," one of the hundreds of artists who shaped America: "22! There goes Loewy!"

"Atlanti

"Pacific

"Prairi

"Adriati

"Baltic

"França

L'effort de traction à la jante est donnée par la form

$$T = p \frac{d^2 l}{D}$$

{ p = la pression à la
{ d = le diam. des cyli
{ l = la course des pist
{ D = diam. des roues mo

Résistance d'un train

proportionne à 10 et à l'heure

70

100

Locomotives

Type Atlantic { bogie à l'avant
4 - 4 - 2 (86ᵗ { 2 roues couplées
{ essieu porteur à l'Ar.

type Pacific { bogie à l'AV
4 - 6 - 2 (95ᵗ { 3 essieux couplés
{ essieu porteur à l'AR

type Prairie { bissel à l'AV
2 - 6 - 2 { 3 roues couplées
{ essieu porteur à l'AR

surface de grille : 4ᵐ²25 (en palier
timbre : 16 kg { 400 tonnes
roues motrices : 1,95, 2,05ᵐ { à 110 km à
surface de chauffe : 286 ᵐ·q { l'heure)
8 tonnes par essieu en moyenne
prix : environ 175.000ᵗ (1/80) le Kg

Type Adriatic { Le premier essieu moteur
{ et le bissel forment bogie
4 - 4 - 4 { 4 roues couplées
{ boggie à l'AR .

type Baltic { compound 4 cyl. avec surchⁱ
{ 1.855 CH en vitesse
4 - 6 - 4 (102ᵀ { + de 2.000 au démarrage

1 Litre = 1.000 cm³

Pacific. P. L. M.. Simple expansion, 4 cyl.
égaux, 12 kg de pression, surchauffe
Longueur des Loco. Pacific ,14ᵐ
sortie d'air, poids : 1ᵏ293

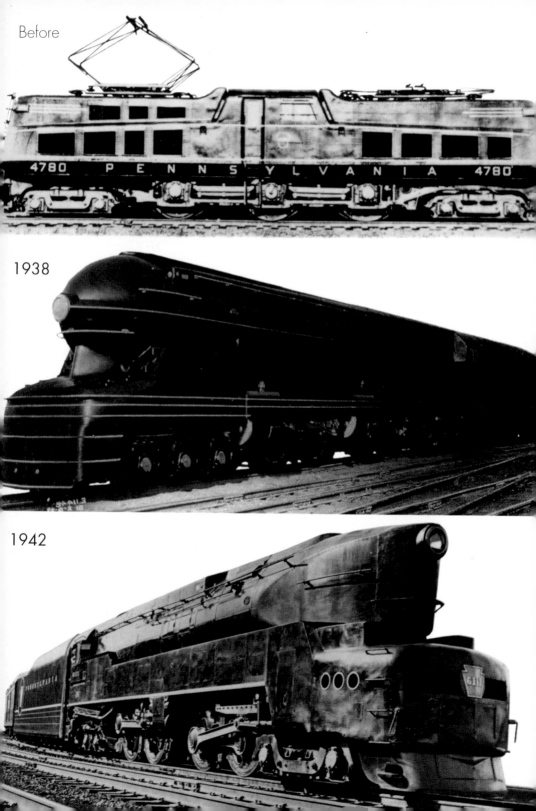

Before

4780 P E N N S Y L V A N I A 4780

1938

1942

6111

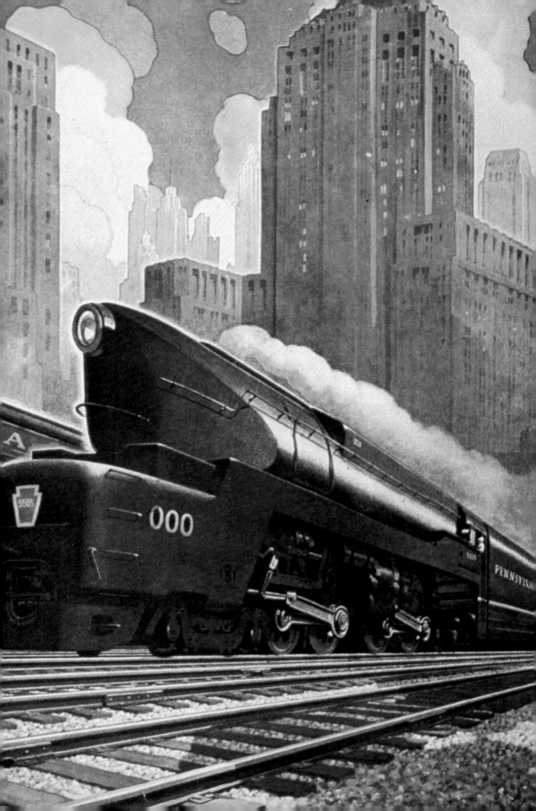

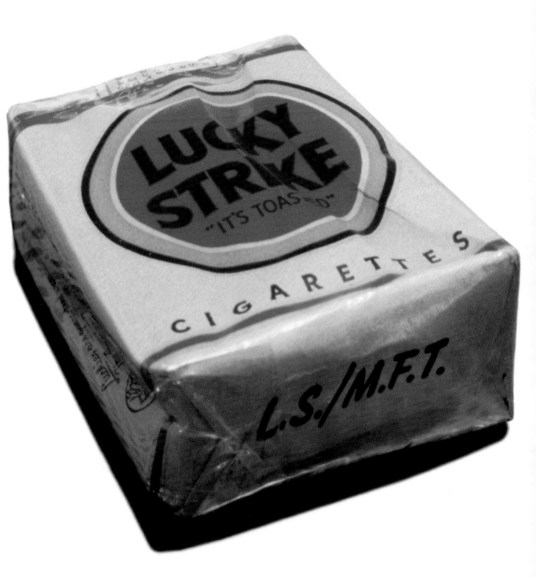

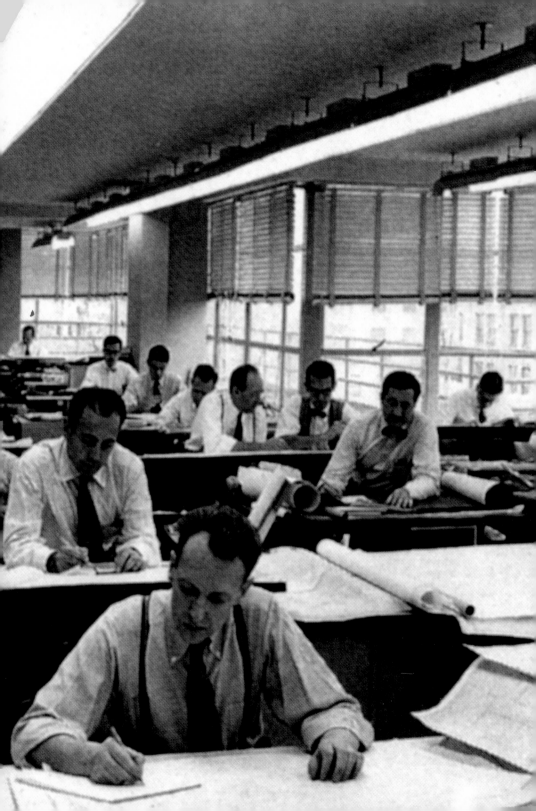

1900

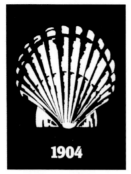

1904

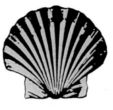

1909

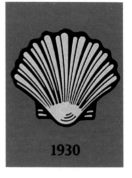

1930

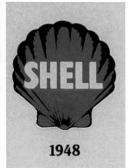

1948

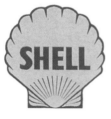

1955

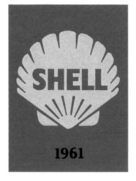

1961

1971

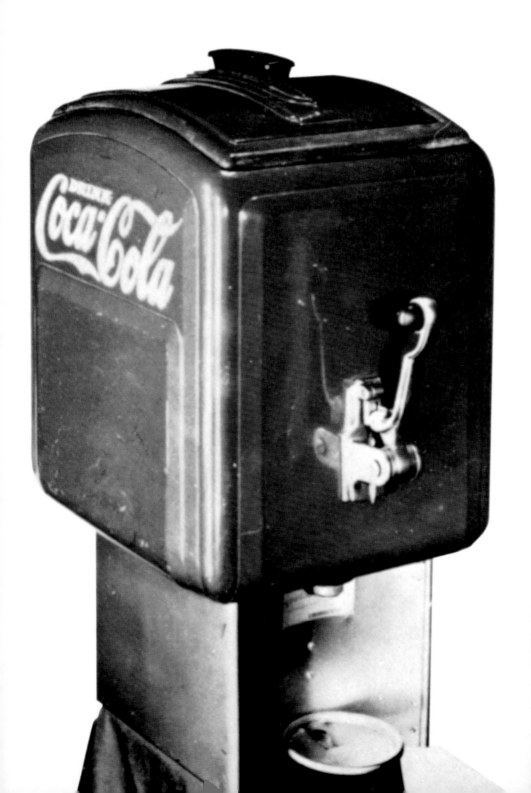

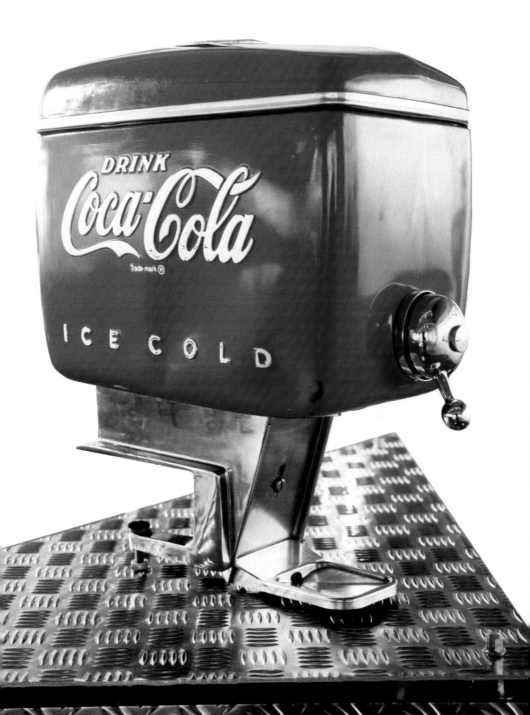

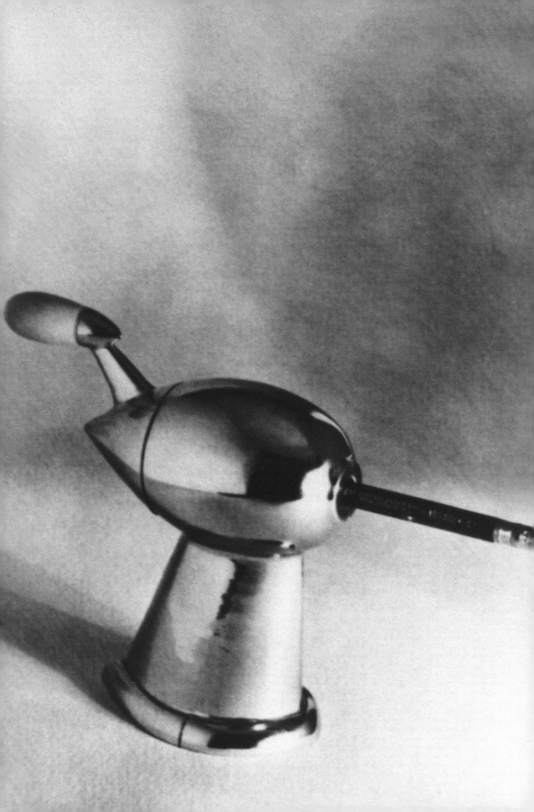

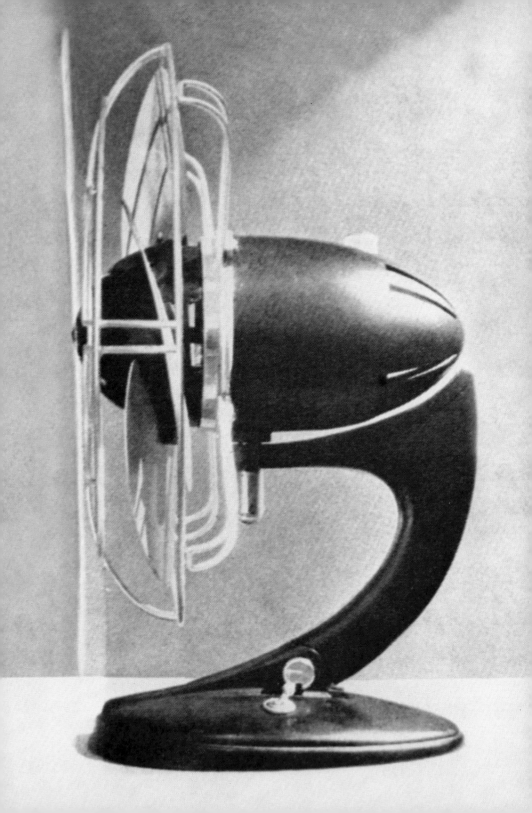

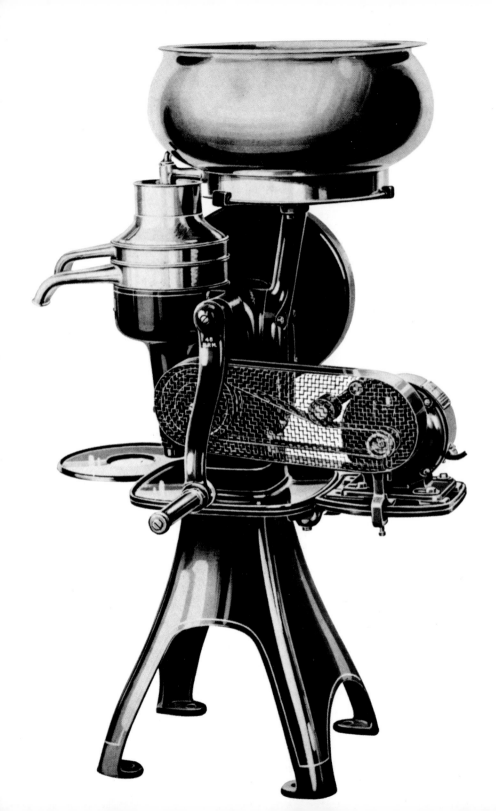

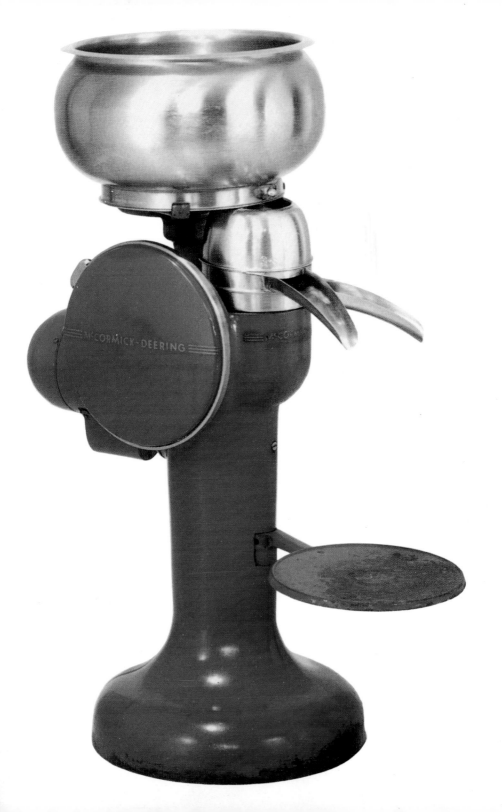

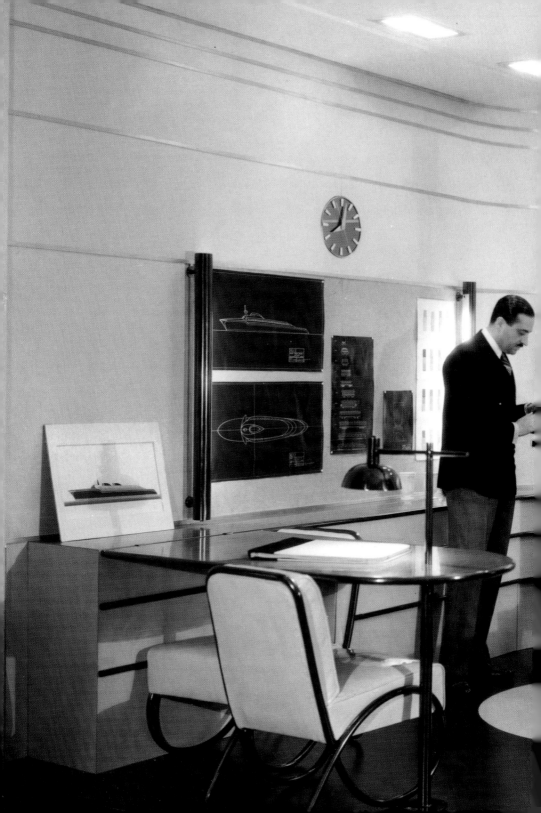

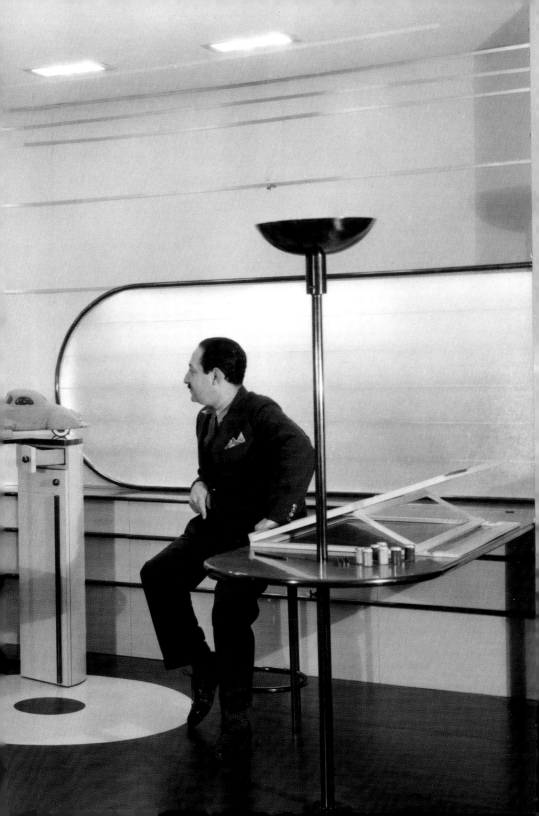

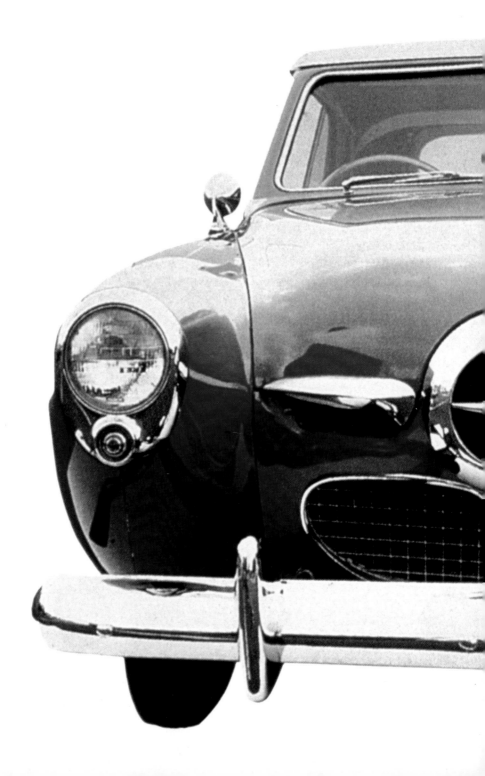

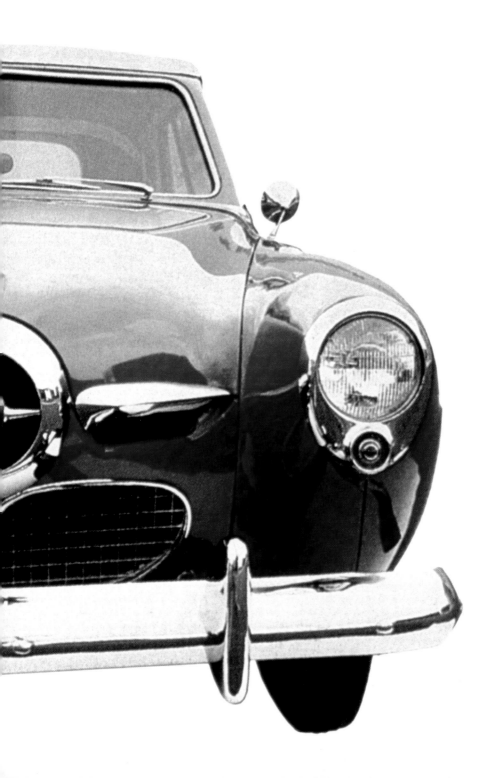

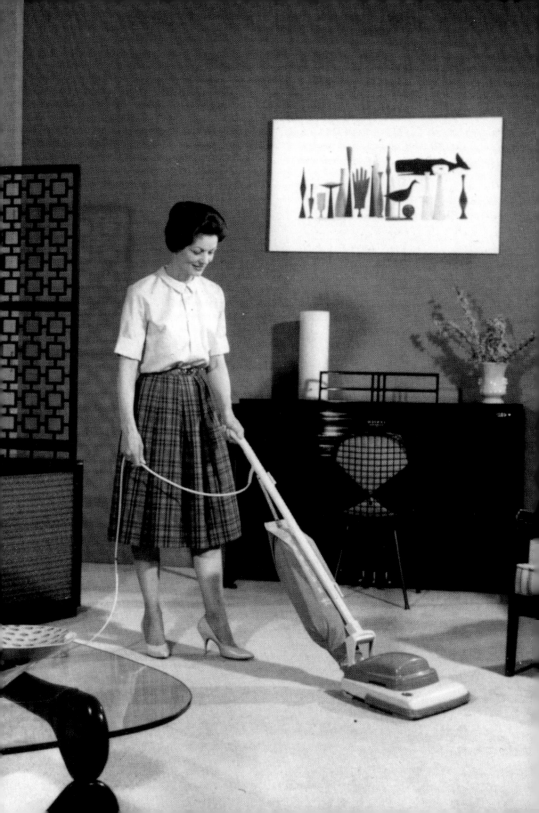

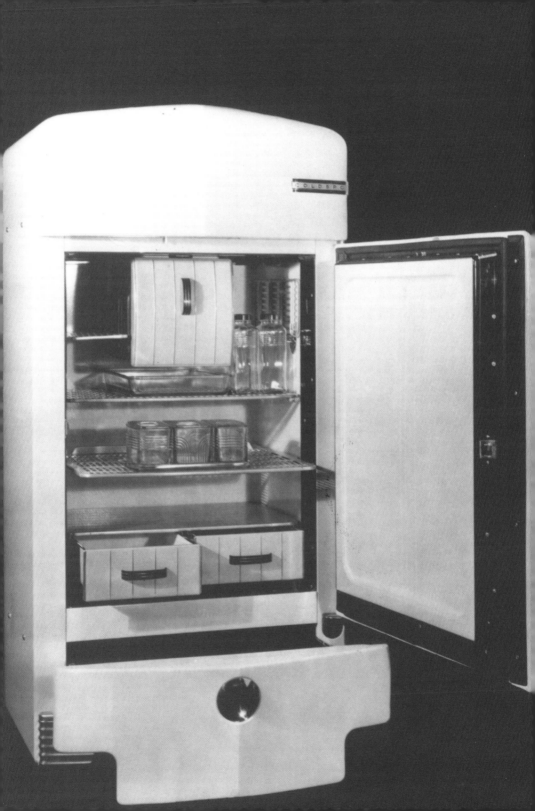

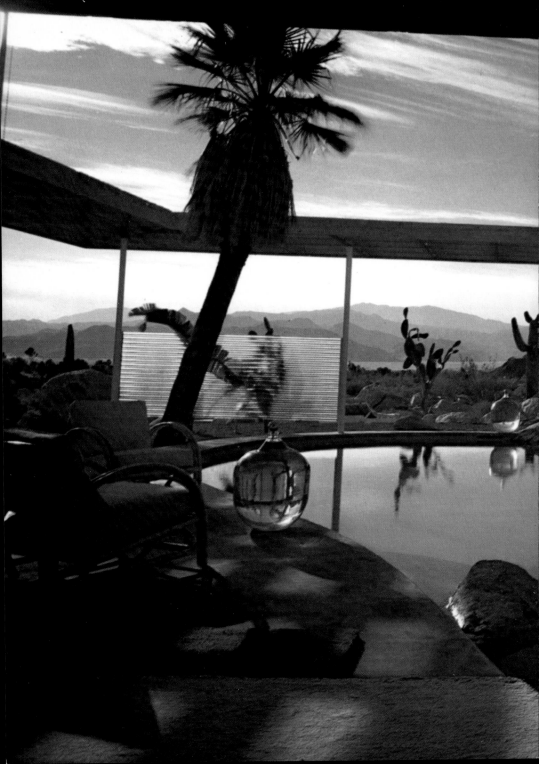

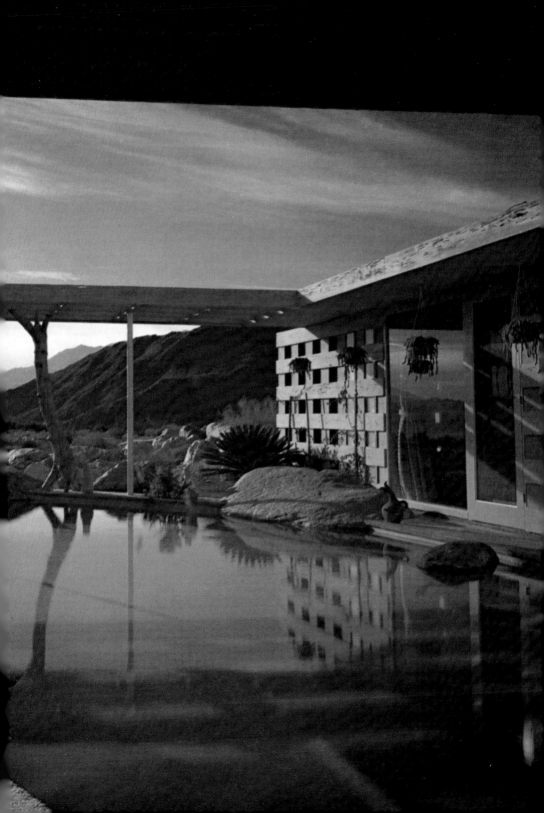

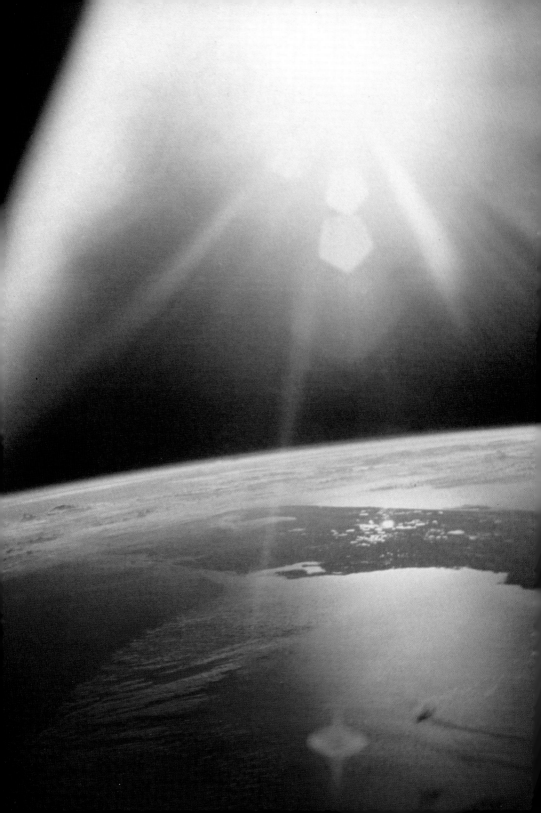

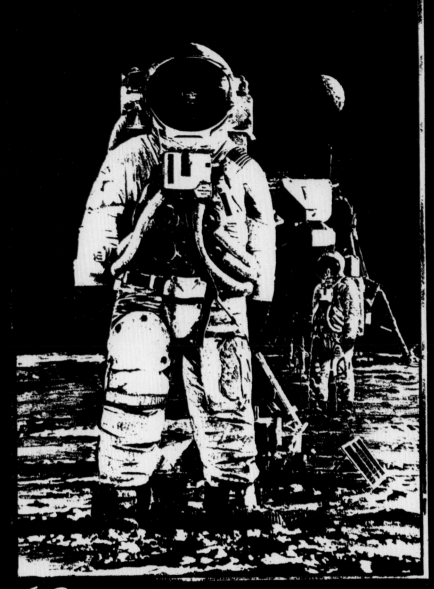

To Raymond Loewy
Thanks for your contributions to the U.S. Space
Program from The Apollo XI Crew

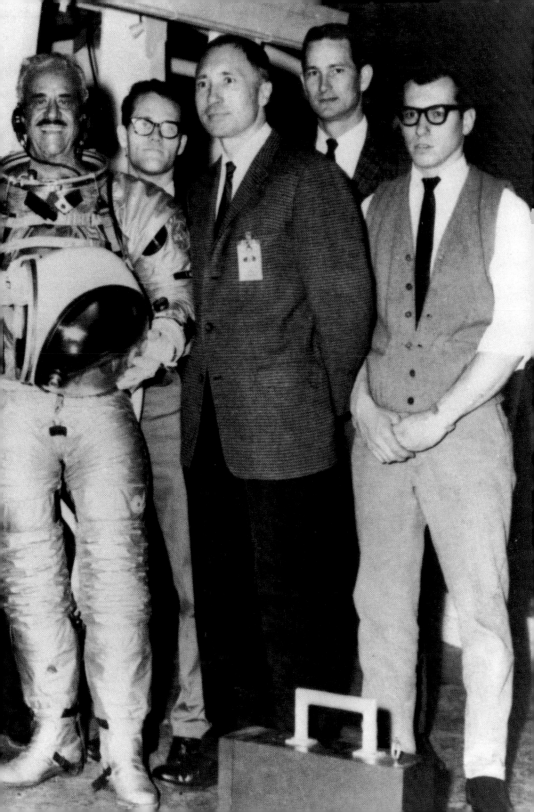

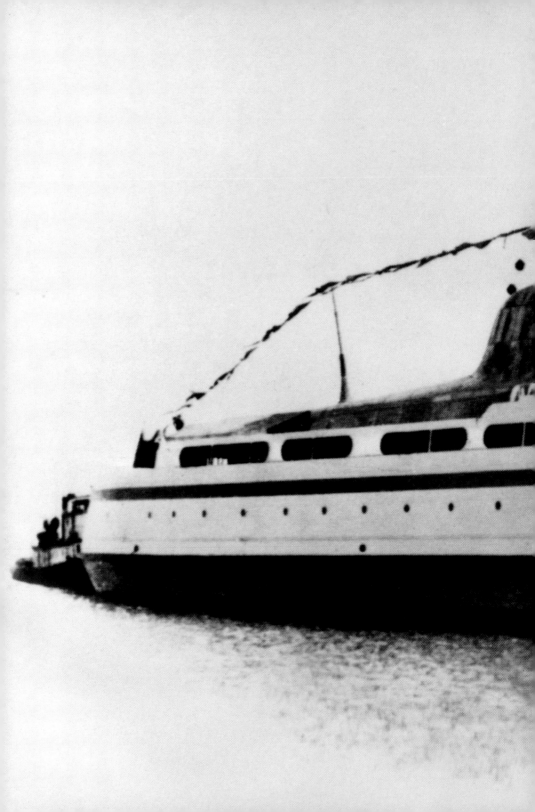

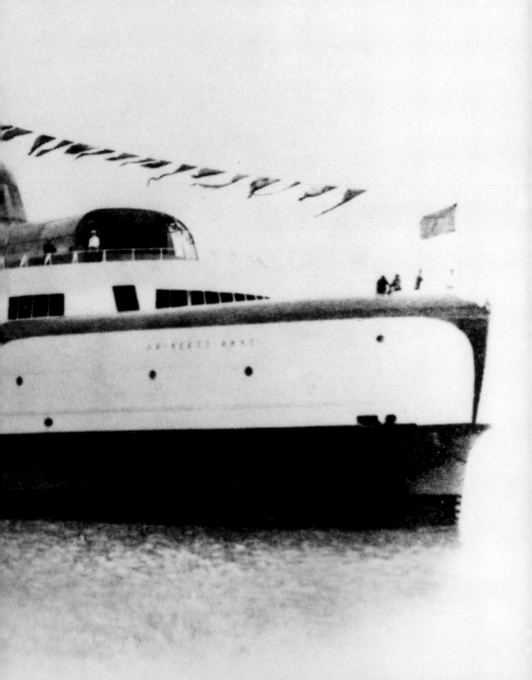

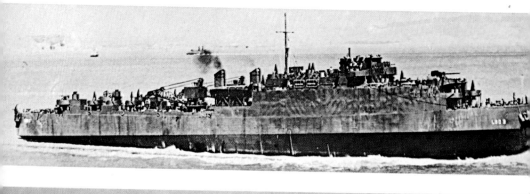

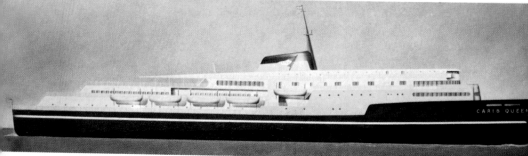

Before / After

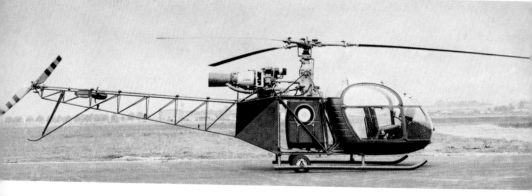

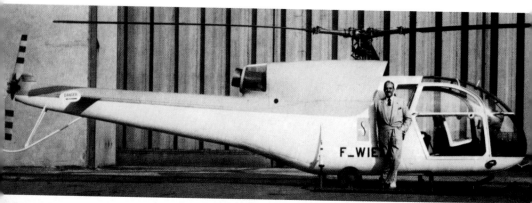

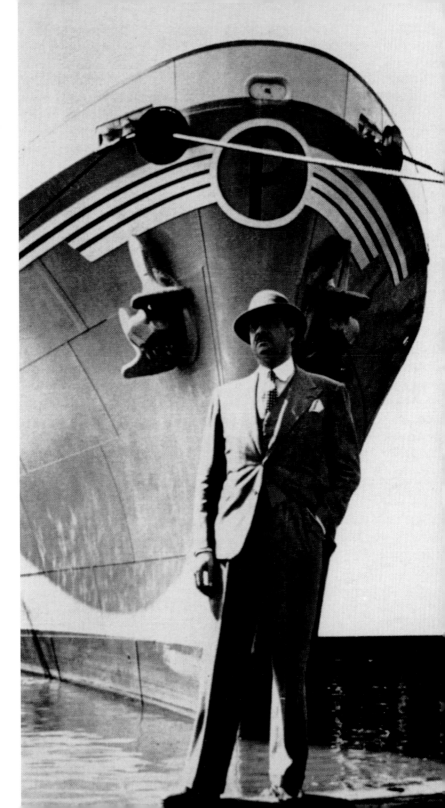

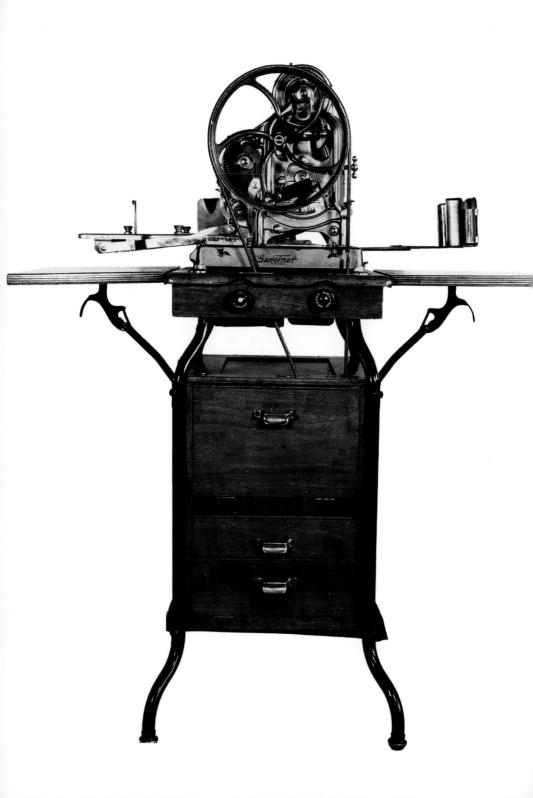

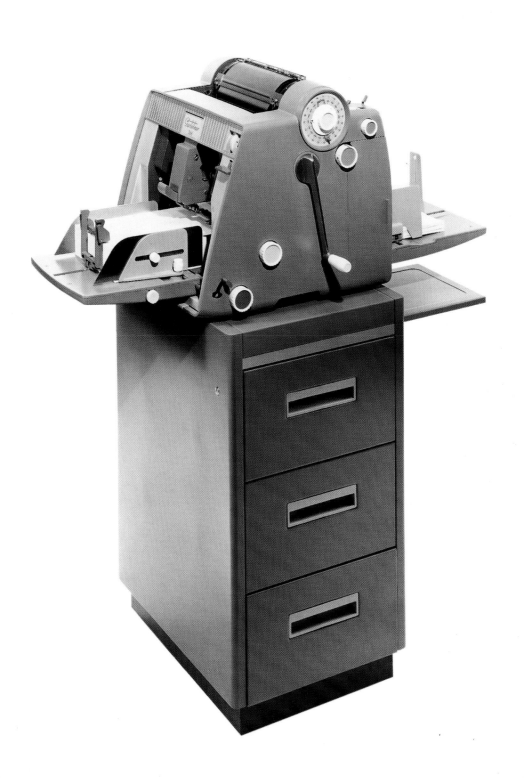

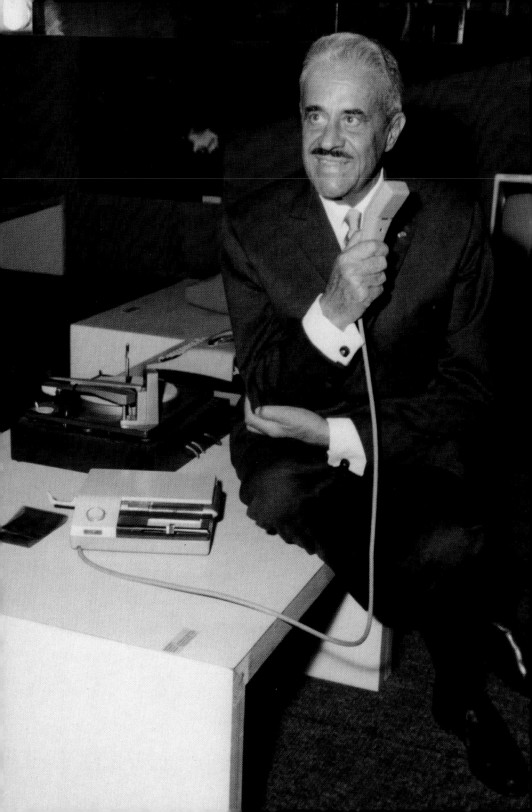

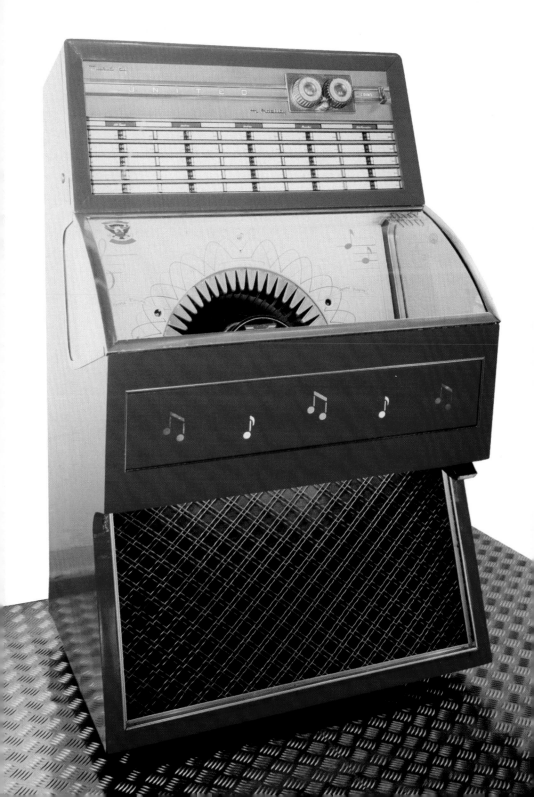

EXXON

march 1966
Palm Springs - cal

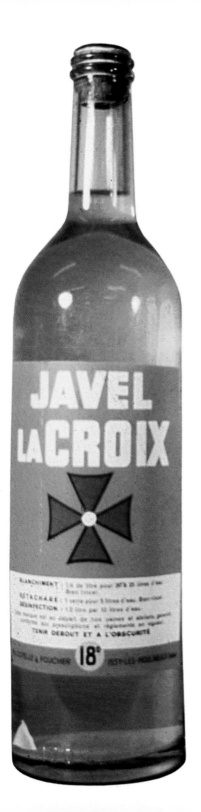
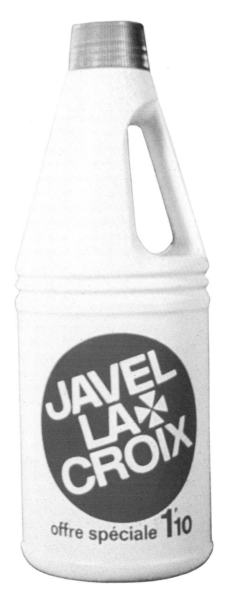

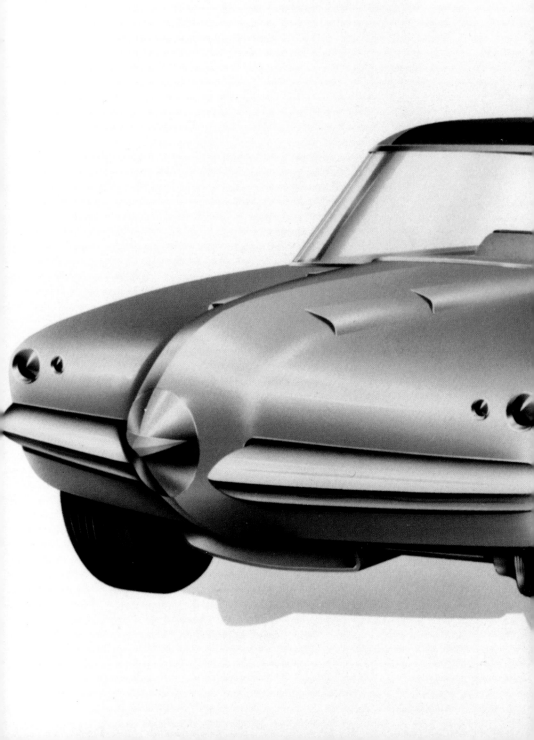

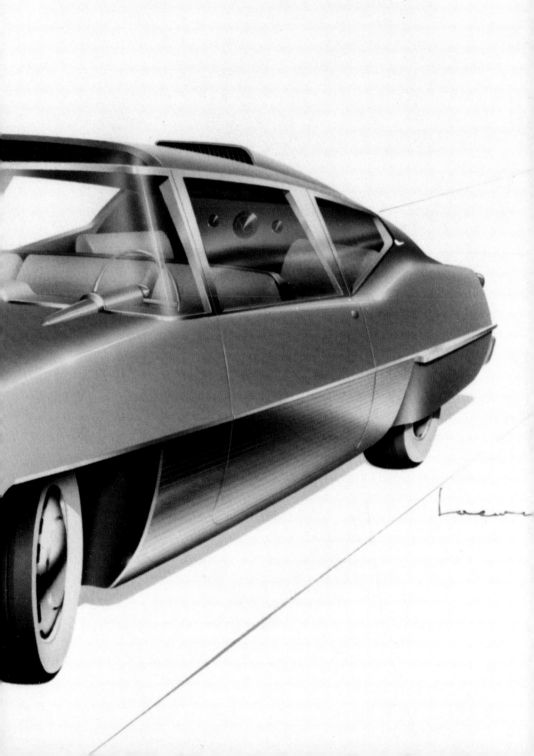

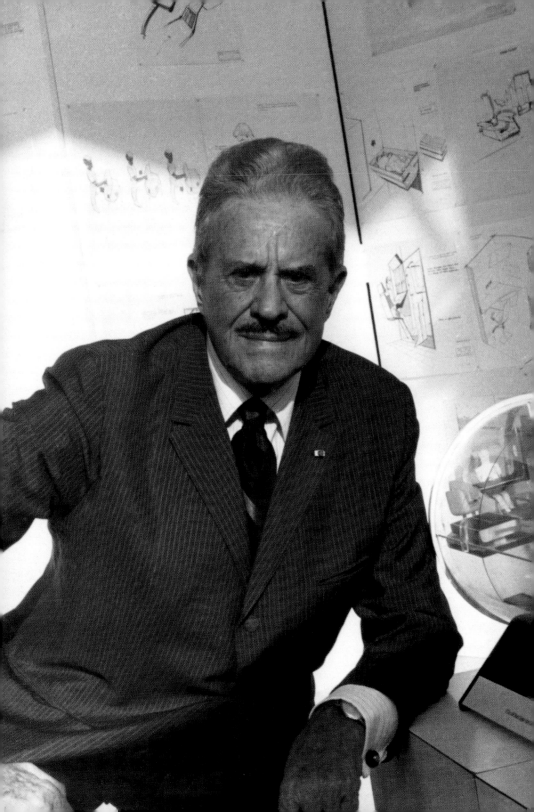

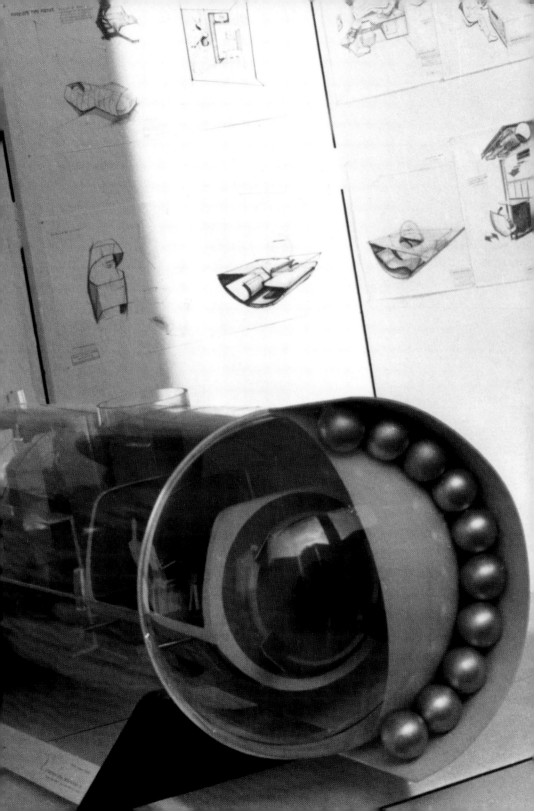

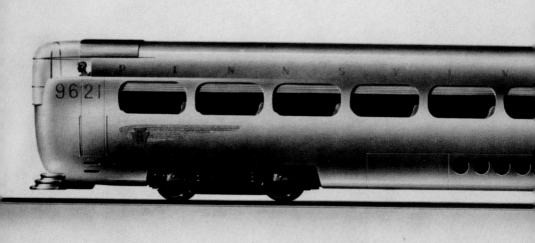

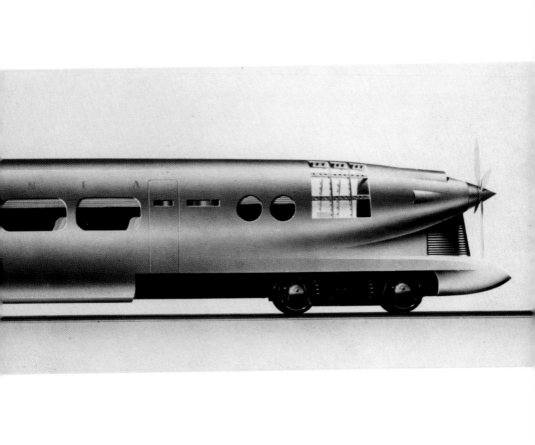

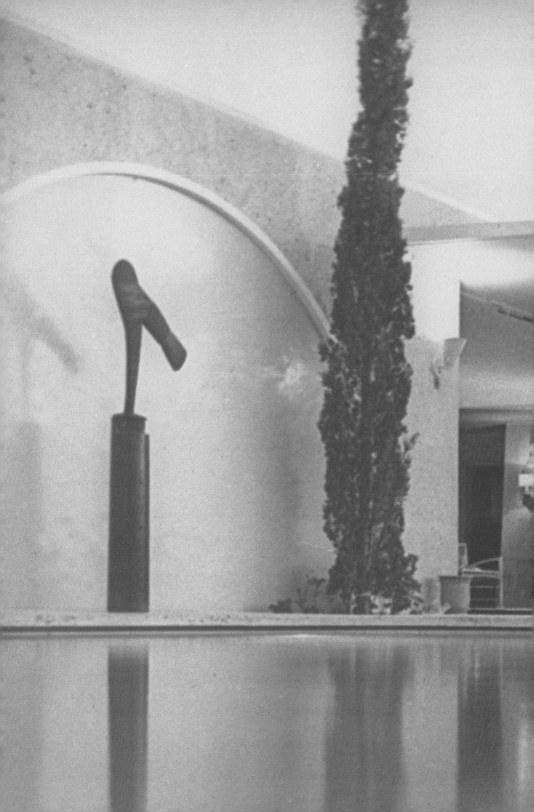

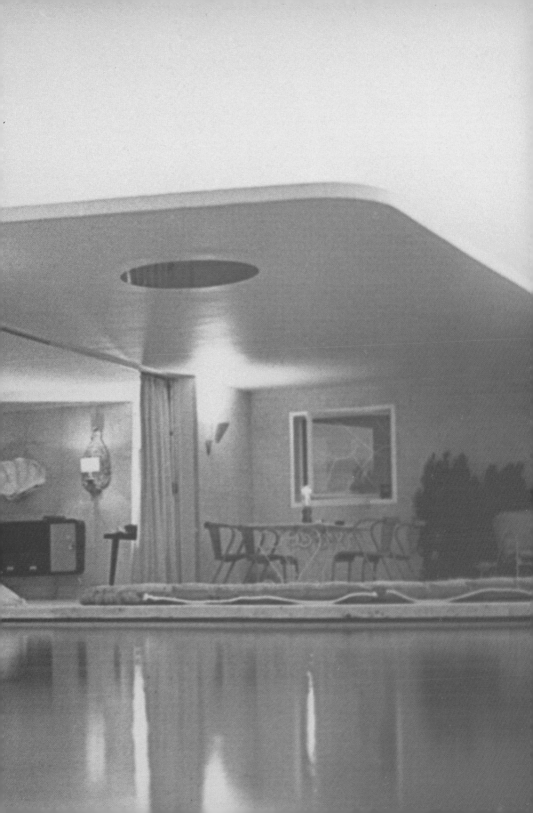

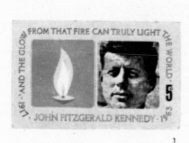

1

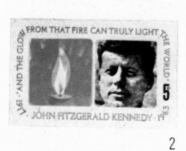

2

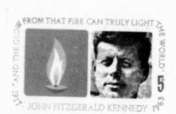

3

Try darker blue

Darker blue grey
(Slate.)

Try This.

Raymond Loewy

march 1964.

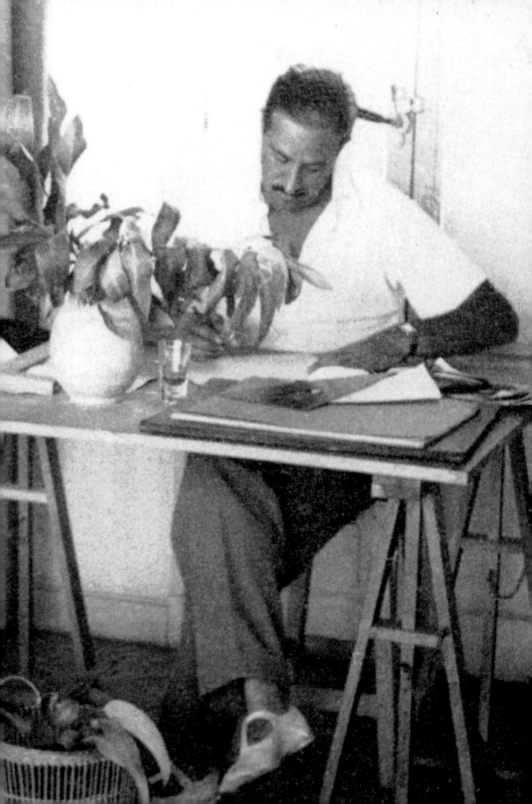

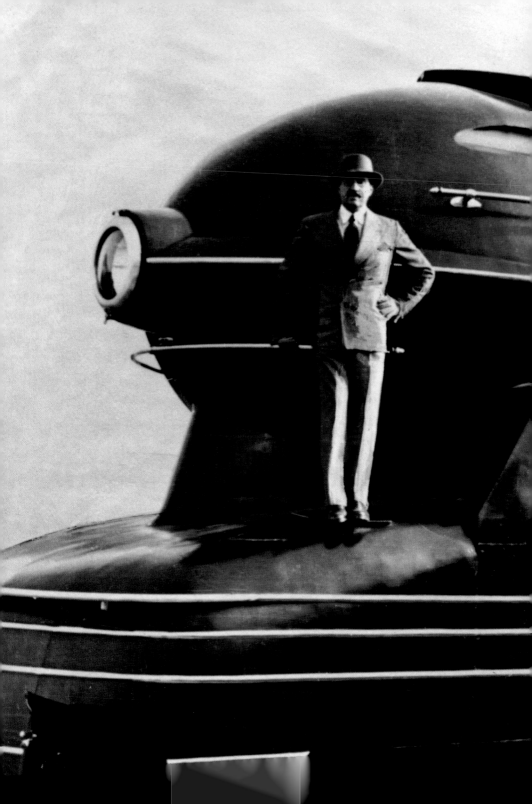

LOEWY

RAYMOND LOEWY
1893-1986
PIONIER DES
AMERIKANISCHEN
INDUSTRIE-DESIGN
**AKADEMIE
DER KÜNSTE
HANSEATENWEG 10**
BERLIN 21
17. MÄRZ BIS
22. APRIL 1990
DI-SO 10-20 UHR
MI EINTRITT FREI
BUS 16
U-HANSAPLATZ
S-BELLEVUE

INTERNATIONALES
DESIGN ZENTRUM
BERLIN E.V.
UNTERSTÜTZT
DURCH
DAIMLER-BENZ AG
DEUTSCHE
LUFTHANSA AG
LUCKY STRIKE
STIFTUNG
DEUTSCHE
KLASSENLOTTERIE

IDZ

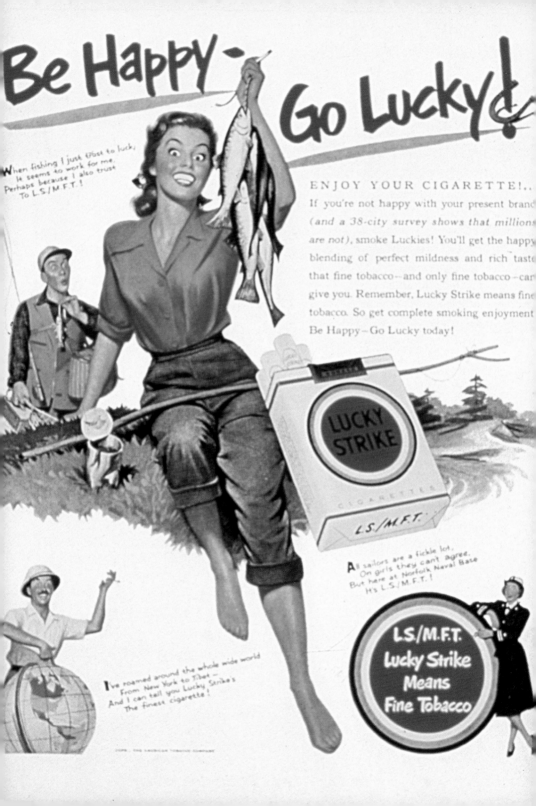

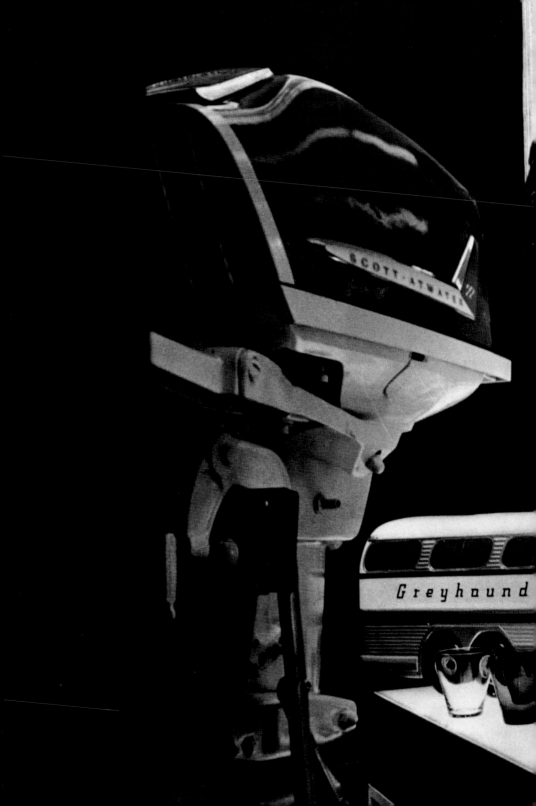

SHELL
MAGAZINE

2/68

All wrapped up

Chronology

1893: Raymond Loewy is born in Paris.

1914-1918: Loewy serves in the French army.

1919: Loewy leaves for New York where he is hired as a window designer at Macy's. Soon after he makes his way into the creative world as a fashion illustrator for *Vogue* and *Harper's Bazaar*.

1929: Gestetner commissions Loewy to modernize the duplicating machine.

1931: Loewy marries Jean Thomson.

1932: He designs the Hupmobile for the Hupp Motor Company, his first car order.

1933: Together with Lee Simonson, Loewy opens the Designer's Office and Studio in New York, at 500 Fifth Avenue. The business specializes in product, transportation and packaging design.

1934: The Metropolitan Museum of Art New York organizes the Contemporary American Art Exhibit, in which it presents works from Loewy's office. The London design agency opens. The *Hupmobile* is produced.

1935: Loewy creates designs for the Greyhound bus and Sears Roebuck's Coldspot refrigerator for Sears Roebuck.

1936: Together with naval architect George C. Sharp, Loewy designs the *Princess Ann* liner for the Railway Steamship Company.

1937: The Architecture and Interior Design department is added to Loewy's New York office. He designs locomotives for the Pennsylvania Railroad Company and receives the Gold Medal in Transportation for his designs of the GG1 locomotive shown at the Exposition Internationale des arts et techniques de Paris.

1938: Loewy becomes a naturalized American citizen. The Chicago office opens, and he begins working with Studebaker and Coca-Cola.

1939: Loewy designs the Electrolux vacuum cleaner. Several of his creations are presented at the World's Fair in New York where the S1 locomotive is a particular success.

1942: Loewy redesigns the Lucky Strike packet. He is made officer of the French Legion of Honor.

1944: Loewy establishes Raymond Loewy Associates in New York.

1945: He divorces Jean Thomson.

1946: Loewy becomes president of the American Society of Industrial Design, which he had founded two years earlier.

1947: The Studebaker Company's Champion model, designed by Loewy, is launched in the American market. He designs the Coca-Cola dispenser.

1948: Loewy marries Viola Erickson.

Raymond Loewy and the designers from the Compagnie de l'esthétique industrielle (CEI). © Archives Evert Endt, Paris.

1949: *Time* dedicates a cover and feature article to Loewy. The Raymond Loewy Corporation specializing in architecture is established, in association with the New York business.

1951: Loewy's autobiography *Never Leave Well Enough Alone* is published. It is translated into French in 1953 under the title *La Laideur se vend mal* (Gallimard, coll. "Tel", 1990).

1952: Loewy establishes the Compagnie de l'esthétique industrielle (CEI) that specializes in designing banks and department stores.

1953: The *Starliner*, a Studebaker Company model designed by Loewy, arrives on the market. The German translation of Loewy's autobiography is a best-seller. A major article about him appears in *Der Spiegel*, which awards him their "Medal of Good Taste."

1954: Loewy designs the *Scenicruiser* for Greyhound.

1958: The French Chamber of Commerce in the United States names Loewy vice president.

1961: The Committee of Science and Technology of the Soviet Union invites Loewy to Moscow.

1962: Loewy designs the Avanti sports car, his last car for the Studebaker Company.

1964: The John Fitzgerald Kennedy commemorative stamp is designed by Loewy.

1965: Loewy creates the corporate identity for British Petroleum (BP).

1967-1973: Loewy designs the Skylab cockpits for NASA.

1969: The London office is reopened. Poor economic conditions had forced its closure in 1951. *The Sunday Times* calls Loewy "One of the Thousand Makers of the Twentieth Century."

1971-1974: Loewy creates the look for Shell's stations, gas pumps and work clothes.

1974: The USSR commissions CEI to design the *Moskwitsch* car. Loewy designs cans for Heinz and cigarette packets for Lambert & Butler.

1975: The Renwick Gallery in Washington organizes the first retrospective of Loewy's work.

1976: For the U.S. bicentennial celebrations, the Smithsonian Institution prepares a list of the "One Hundred Events that have Shaped America." Loewy appears beside Bell, Edison, Ford and other such luminaries.

1981: Following dissension among members of his team, CEI is taken over by one of Loewy's first colleagues, Renée Labaume and is renamed Nouvelle CEI.

1986: Raymond Loewy dies in Monaco.

1990: In Paris, the Centre de création industrielle (CCI) presents an exhibit at the Centre Georges-Pompidou entitled "Raymond Loewy (1893-1986), un pionnier du design américan."x

Raymond Loewy sitting on the Concorde in 1973. He designed the plane's interior.
© Archives Evert Endt. Paris.

Loewy

A page from Raymond Loewy's notebook.

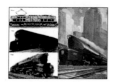

Locomotives from the Pennsylvania Railroad Company. Left: current model the S1 (R. Loewy, 1938) © Archives Evert Endt, Paris; the T4 (R. Loewy, 1942) © Archives Evert Endt, Paris; Right: the Steam T1 (1942), publicity for the Société des chemins de fer for its 100th anniversary in 1946 © Mnam/CCI, Centre Georges-Pompidou, Paris. From a very young age, Loewy was fascinated by speed, and specially by locomotives.

The Lucky Strike packet, replaced and improved by Raymond Loewy in 1943, represented his best calling card. Even though the visual impact of the original package seemed unbeatable, this certainty soon went up in smoke. © AKG, Paris (left);

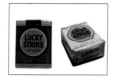

Madison Avenue design studio, circa 1955.
Development of the Shell logo. © Shell's company archives.
Packaging for LU biscuits, R Loewy, 1957. © Mnam/CCI, Centre Georges-Pompidou, Paris. In the 1960s, Loewy's Compagnie de l'esthéthique industrielle, with its hundreds of employees, was the biggest design company in the world.

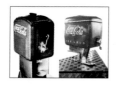

Coca-Cola dispenser, before and after 1947, when it was redesigned by Raymond Loewy. While he cannot be credited with the design or redesign of Coca-Cola's most famous bottle (the small version), he did work with the larger container and was asked to rethink the design of dispensers for bars and delivery trucks. © AKG, Paris (right).

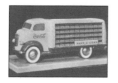

Delivery truck with angled racks to facilitate handling, by Raymond Loewy.

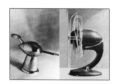

Pencil sharpener, Raymond Loewy, 1933.
Fan, by Raymond Loewy. The inventor of what was to be called organic architecture Loewy will always be heralded as the master of streamlined design. In contrast to the functionality and right angles favored by members of the Bauhaus movement, he preferred refined shapes and rounded corners. © Archives Evert Endt, Paris.

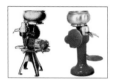

McCormick-Deering Creamer before and after it was redesigned in 1945. The updating of this creamer clearly reflects Loewy's design approach: elimination of fragile parts, encasements with bright colors, simplification. © All rights reserved.

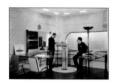

Mock-up of Raymond Loewy's office at the Metropolitan Museum of Art, New York, 1934. Photographs such as this were systematically taken of the designer's various apartments and offices and distributed to the international press. © Archives Evert Endt, Paris.

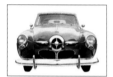

Commander Regal de Luxe car from the Studebaker Company, 1950. The Studebakers designed by Loewy impacted the development of American car design. The Italian influence is visible here in the compactness of the body and the style of the hood. Resembling a locomotive, the "bullet style" is duplicated in the radiator grill. Despite the desirable features of their cars, the company went bankrupt. © Mnam/CCI, Centre Georges-Pompidou, Paris.

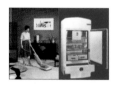

American living room of the 1950s. Vacuum cleaner from the Hoover company designed by Henry Dreyfuss.
Coldspot refrigerator from the Sears Roebuck Company, designed by Raymond Loewy in 1935. From vaccum cleaners, to refrigerators-Loewy took on all the pieces that would eventually shape the American way of life. © All rights reserved (left); © Mnam/CCI, Centre Georges-Pompidou, Paris.

Loewy's House, which he designed and in which he lived for 40 years in the desert near Palm Springs California. © All rights reserved.

View from Florida during the apollo flight. © Photo: NASA. **Thank you note sent to Raymond Loewy** by the crew of Apollo 11, 1969. © All rights reserved. Asked to work on the design of the space shuttle, Loewy recommended that a porthole be placed in the astronauts' cabin. The views subsequently afforded of the Earth generated enormous enthusiasm that future generations will continue to share. Upon their return, the crew expressed their gratitude to the designer.

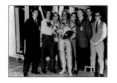

At Cape Canaveral, about 1969, raymond Loewy, who never missed an opportunity to be in the spotlight during his long career, tries on a space suit for a group of NASA employees. © Archives evert Endt, Paris.

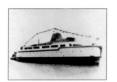

Princess Ann ferryboat (1936), commissioned from Loewy by the Virginia Ferry Corporation. In 1940, Architectural Forum wrote that Raymond Loewy was the only person who could travel across the United States in a vehicle of his own design, whether train, boat, or car. © Mnam/CCI, Centre Georges-Pompidou, Paris.

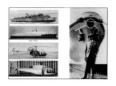

American landing craft used during World War II. The carib Queen is converted from a war ship to a cruise ship (1954). **The new fuselage for l'Alouette.**
Loewy posing in front of the bow of the *Princess Ann* in 1936. During the war, the Loewy workshops helped to camouflage landing crafts. When the war ended, Loewy tackled the task of converting battle vessels into cruise ships. © All rights reserved.

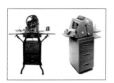

Gestetner duplicating machine: 1908 model (left) and latest model designed by Loewy for the company in 1976 (right). The transformation of the Gestetner copy machine was the first major commission won by Loewy and launched his career. Half a century later, he was still designing products for the company. © Gestetner archives.

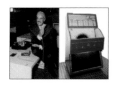

Dictaphone (1965). Jukebox (1957). In 1965, Raymond Loewy won first prize at the Industrial Design Competition for this dictaphone. © Keystone, Paris (left); © AKG, Paris (right).

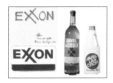

Plans for Exxon, original sketches and logo by Raymond Loewy, 1966.
Javel La Croix logo before and after it was redesigned by Loewy in 1964. in addition to working on corporate logos, Loewy tackled packaging and publicity, updating product images with his talent for combining ergonomics and visual impact. © Archives Evert Endt, Paris (left); © Mnam/CCI, Centre Georges-Pompidou, Paris (right)...

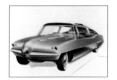

Concept car, by Raymond Loewy, 1945. The designer penned the plans for a number of concept cars that were never built. © Archives Evert Endt, Paris.

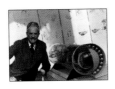

Raymond Loewy with one of his space rocket models at the ORTF exhibit in 1970. Known as a bit of a fabricator, he did not quell the rumor that he had designed the Coca-Cola bottle. He also arranged it so that he got a major portion of credit for authorship of the space program. This mischievous side of his personality added to the legend of this creative genius. © Keystone, Paris.

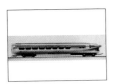

Streamlined locomotive for Pennsylvania Railroad. Raymond Loewy, a fan of compact design, drew up this plan in 1932. © archives evert Endt, Paris.

Raymond Loewy's Saint-Tropez summer residence, acquired in 1930, was laid out in Japanese style by the designer himself. © All rights reserved.

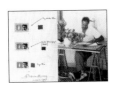

John Fitzgerald Kennedy commemorative stamp, by Raymond Loewy, 1964. The designer mixed with the international jetset and could thus claim that he secretly gave Kennedy the idea of conquering the new frontier of space. © All rights reserved.
Raymond Loewy in 1935. © All rights reserved.

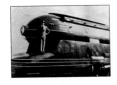

Raymond Loewy posing at the flank of S1 locomotive in 1939. This picture is reminiscent of the one this "fashion plate" would appear in decades later decked out in an astronaut suit. © All rights reserved.

Publicity for Lucky Strike cigarettes, circa 1950. Loewy accompanied the launch of the revamped Lucky Strike packet with a publicty campaign that promoted the image of good health. © Mnam/CCI, Centre Georges-Pompidou, Paris.
Sketch for a poster announcing the exhibit dedicated to Loewy in Berlin in 1990. Even without bearing his name, the Lucky Strike packet is immediately recognizable, its bull's-eye effect reminiscent of Jasper johns. © AKG, Paris.

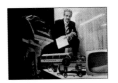

Raymond Loewy with some of his creations in the 1950s, including bottles, trains, planes and television sets. © Archives Evert Endt, Paris.

The publishers would like to thank Evert Endt, co-director between 1960 and 1975 of the Compagnie de l'esthéthique industrielle (CEI/R. Loewy, Paris) for the help he has given in the preparation of this work. We would also like to thank Maurice Auschitzky and Corine Evesque (Sociéte des Pétroles Shell), Bernard Garrett and Renate Benecke (AKG, Paris), Jacques Nicolleau (Keystone), Geneviève Saint-Genieis (Gestetner, Communications division) and Christine Sorin (Mnam Documentation, Centre Georges-Pompidou).